1 MONTH OF
FREE
READING

at
www.ForgottenBooks.com

By purchasing this book you are eligible for one month membership to ForgottenBooks.com, giving you unlimited access to our entire collection of over 1,000,000 titles via our web site and mobile apps.

To claim your free month visit:
www.forgottenbooks.com/free907509

* Offer is valid for 45 days from date of purchase. Terms and conditions apply.

ISBN 978-0-265-90478-7
PIBN 10907509

This book is a reproduction of an important historical work. Forgotten Books uses state-of-the-art technology to digitally reconstruct the work, preserving the original format whilst repairing imperfections present in the aged copy. In rare cases, an imperfection in the original, such as a blemish or missing page, may be replicated in our edition. We do, however, repair the vast majority of imperfections successfully; any imperfections that remain are intentionally left to preserve the state of such historical works.

Forgotten Books is a registered trademark of FB &c Ltd.
Copyright © 2018 FB &c Ltd.
FB &c Ltd, Dalton House, 60 Windsor Avenue, London, SW19 2RR.
Company number 08720141. Registered in England and Wales.

For support please visit www.forgottenbooks.com

CATALOGUE

OF

A VERY IMPORTANT COLLECTION

OF

ANTIQUE PAINTINGS

PROPERTY OF

MR. MORTIMER GREEN

TO BE SOLD AT

ABSOLUTE PUBLIC SALE

On Thursday and Friday Evenings,

April 28th and 29th, 1904,

promptly at 8.15 o'clock.

AT THE

FIFTH AVENUE ART GALLERIES

866 FIFTH AVENUE, NEW YORK.

JAMES P. SILO, - AUCTIONEER.

CONDITIONS OF SALE

1. The highest bidder to be the buyer, and if any dispute arise between two or more bidders, the lot so in dispute shall be immediately put up again and resold.

2. The purchasers to give their names and addresses and to pay down a cash deposit, or the whole of the purchase money, *if required*, in default of which the lot or lots so purchased to be immediately put up again and resold.

3. The lots to be taken away at the buyer's expense and risk upon the conclusion of the sale and the remainder of the purchase money to be absolutely paid or otherwise settled for to the satisfaction of the auctioneer, on or before delivery; in default of which the undersigned will not hold himself responsible if the lots be lost, stolen, damaged or destroyed, but they will be left at the sole risk of the purchaser.

4. The sale of any article is not to be set aside on account of any error in the description. All articles are exposed for public exhibition one or more days and are sold just as they are, without recourse.

5. To prevent inaccuracy in delivery, and inconvenience in settlement of the purchases, no lot can on any account be removed during the sale.

6. If, for any cause, an article purchased cannot be delivered in as good condition as the same may have been at the time of its sale, or should any article purchased thereafter be stolen or misdelivered, or lost, the undersigned is not to be held liable in any greater amount than the price bid by the purchaser.

7. Upon failure to comply with the above conditions, the money deposited in part payment shall be forfeited, all lots uncleared within the time aforesaid shall be resold by public or private sale, without further notice, and the deficiency, if any, attending such re-sale shall be made good by the defaulter at this sale, together with all charges attending the same. This condition is with out prejudice to the right of the auctioneer to enforce the contract made at this sale, without such re-sale if he thinks fit.

JAMES P. SILO, Auctioneer.

LIST OF ARTISTS REPRESENTED

Adams, Albert
Alberts, Gerard
Allegre, R.

Barker, Thomas
Bassi, Francesco
Begyn, Abraham
Bellotto, B.
Bergen, Durk van
Biltius, J.
Bisset, James
Borlly, Louis Leopold
Bonesi, C.
Both, Andries
Bremberg, B.
Breughel, Jan
Burgess, John B.

Caracci, Ag.
Cavalucci, A.
Challe, C. M. A.
Clouet, F.
Cooper, Thomas Sidney
Cotes, Francis
Corot, J. B. C.
Coypel, N. N.
Cranach, Lucas
Crome, John
Crome, J. B.
Croos, A. van

De France, L.
De Heem, Jan David
Delacroix, Eugene
De La Tour, M. Q.
Detroy, J. F.
Diaz, N. V.
Dobson, Wm.
Dolci, Carlo
Dore, Gustave
Drouais, Francois Hubert
Dupre, Jules
Dyck, A. Van

Eeckhout, A. Van der
Eyck, Hubert von

Field, E. Loyal
Fragonard, J. H.

Glover, John
Goyen, Jan van
Greuze, Jean B.
Grimoux, Jean Alexis
Guardi, Francesco

Hals, Frans
Harlow, Geo. Henry
Heda, W. C.
Heil, Jan B. van
Helst, B. Van der
Herring, J. F.
Herrmann, Leo
Heusch, J. de
Holbein, Hans
Hugtenburg, Jan van

Ibbetson, J. C.
Isabey, Eugene L. G.

Janssen, Cornelius
Jervas, Charles
Jongkind, J. B.
Jordaens, Jacob

Kabel, A. Van der
Keyser, T. H. de
Klomp, Albert
Kneller, Sir Godfrey
Koekkoek, J. N.
Largilliere, N. de

Leeuw, Gabriel van
Leys, Baron H.
Loir, Nicholas

Morelli, Bartolemeo
Mueller, John Peter
Mytens, T.

Nattier, J. M.
Nedek, Peter
Neer, A. Van der
Netscher, C.

O'Connor, James

Pater, J. B.
Pieters, John
Poel, E. Van der

Raoux, Jean
Rathbone, John
Ravesteyn, Jan Van
Reynolds, Sir Joshua
Rigaud, H.
Romney, George
Rontbout, I.
Roos, John Henry

Teniers, David
Terburg, G.
Thompson, Wm.
Trevisani, Francois
Trouillebert
Turner, G. H.
Turner, J. M. W.

Unknown, Dutch
Unknown, Old English
Unknown, Raphael & Perugino

Vernet, Claude Joseph
Verryet, Jacques
Verspronck, Jan
Vestier, Antoine
Vinne, A. Van der

Watteau, J. A.
Werff, Adrian Van der
Willems, F.

Ziem, Felix

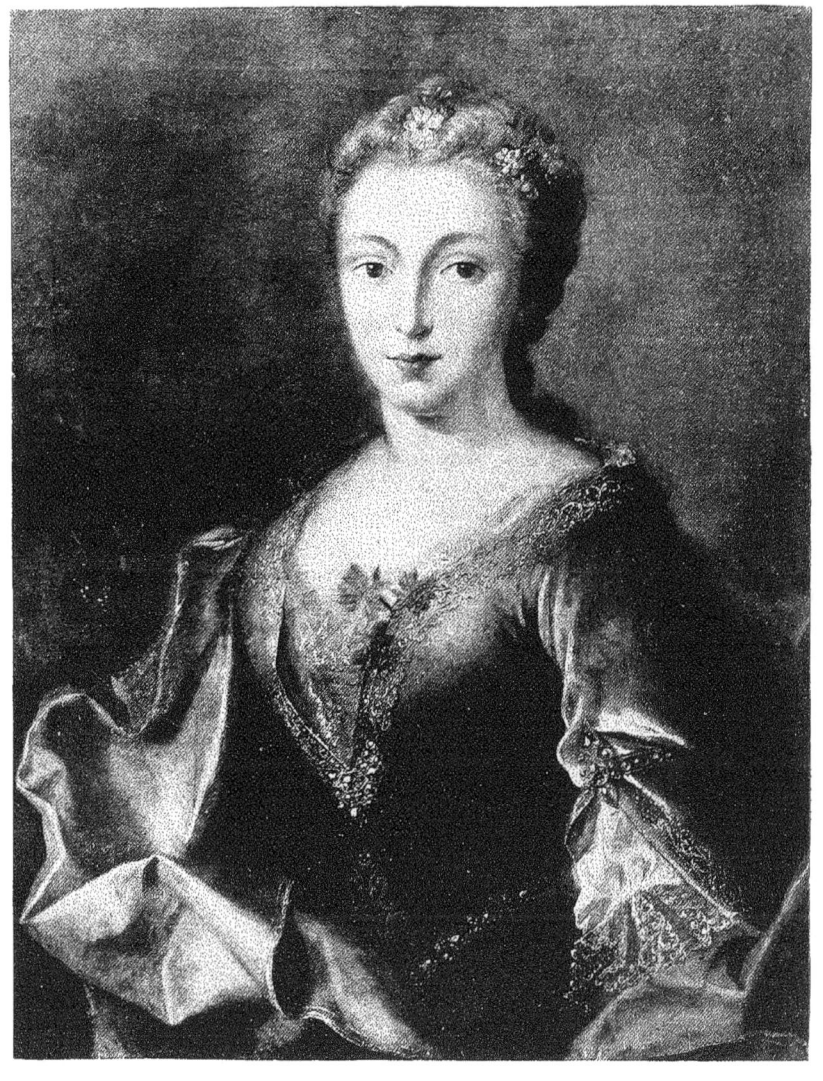

No. 31 J. M. NATTIER

CATALOGUE

FIRST EVENING'S SALE
On Thursday, April 28th, 1904,
at 8.15 o'clock

Eugene Delacroix
1798-1863

The great leader of the French romantic school

1 LION'S HEAD

Water Color—Signed

Leo Herrmann

Contemporary

2 LA BONNE BOUTEILLE

Pen and ink sketch

J. A. Watteau
1684-1721

The greatest master of the French decorative school

3 STUDY OF HEADS

Pencil and crayon sketch

From the collection of the Duc de Chaulnes

A. Cavalucci
1752-1795

Resided at Rome. Imitated the style of Guido Reni

4 ECCE HOMO

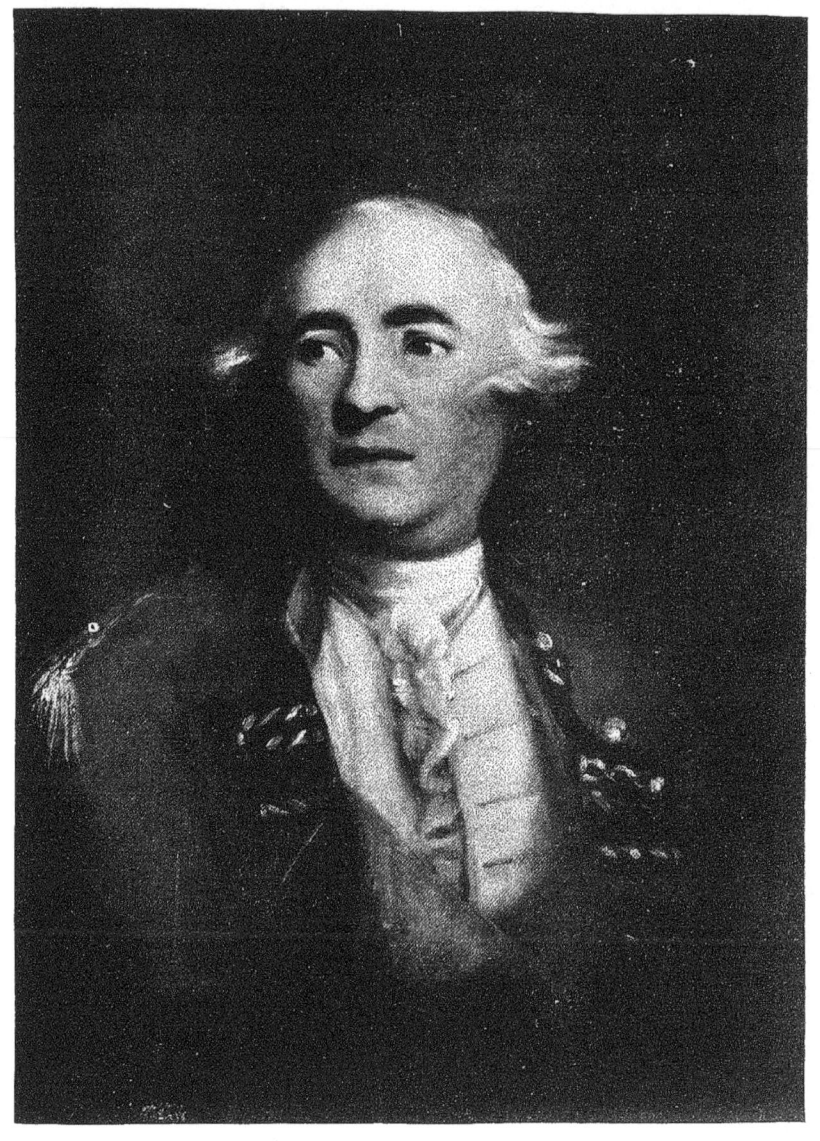

No. 37　　　　　　　　　　　　　　　SIR JOSHUA REYNOLDS

Artist Unknown

6 OLD ENGLISH LANDSCAPE

Francois Trevisani

1656-1746

Italian artist of the late Venetian school

7 GIRL WITH A DOVE

Artist Unknown

Dutch School

8 CHILD'S HEAD

On panel

Jan Breughel

1568-1625

A Flemish artist, first a painter of flowers but afterwards devoted himself to the painting of landscapes

9 LANDSCAPE AND FIGURES

On panel

A. Vestier

1740-1824

10 PORTRAIT OF A LADY

D. Teniers

1610-1694

11 DUTCH INTERIOR

On panel

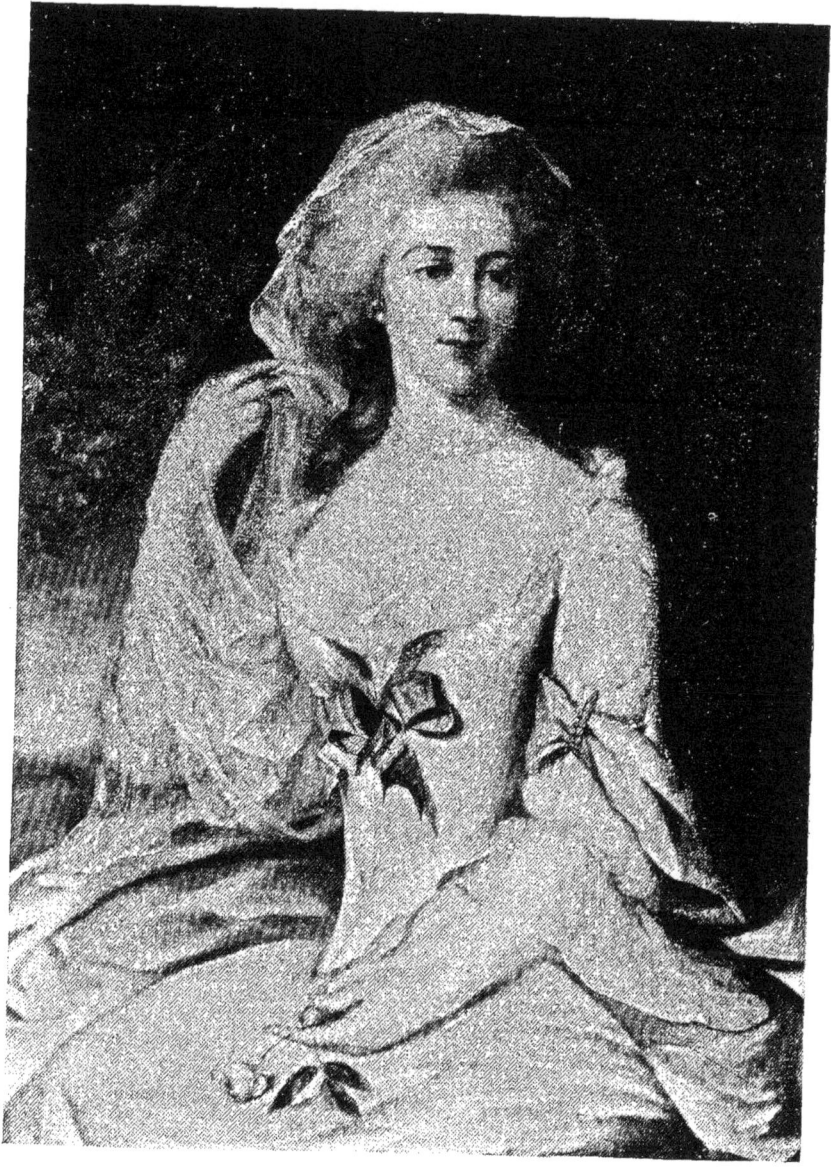

No. 38 FRANCIS COTES

B. Bellotto

1720-1780

Nephew of the famous Canaletto, who was his master. Painted perspective and architectural subjects

12
 (a) AN ITALIAN SCENE
 (b) AN ITALIAN SCENE

J. H. Koekkoek

1778-1850

A Dutch marine painter, father of the living Koekkoeks whose reputation as marine painters is world-wide

13 OFF THE COAST

Trouillebert

Contemporary

14 LANDSCAPE AND MOONLIGHT

On panel

F. Clouet

1510-1572

A French painter whose small portraits
are especially admired

15 PORTRAIT OF A LADY

On panel

John B. Burgess

1829-1899

Elected Associate of the Royal Academy of London
in 1877

16 THE TURNKEY

Alexandre Roslin

1733-1793

17 PORTRAIT OF A LADY

Pierre Mignard

1610-1695

One of the most distinguished portrait painters of the French school. Painted the portrait of Louis XIV. ten times from life, and executed the portraits of the principal nobles, including the Prince of Tuscany, Modena, Parma, etc

18 A COURT LADY

Nicholas Loir

1624-1679

Born in Paris, but developed his talent in Rome where he successfully followed the manner of Nicholas Poussin

19 WOODLAND SCENE

Artist Unknown

20 OLD ENGLISH LANDSCAPE

On panel

V. Van der Vinne

1629-1702

A Dutch portrait painter.
Pupil of Franz Hals

21 A MALE PORTRAIT

On panel

A. Vestier

1740-1824

22 PORTRAIT OF A YOUNG LADY

Jan B. Van Heil

1609-1661

A eminently successful Flemish portrait painter

23 GENTLEMAN'S PORTRAIT

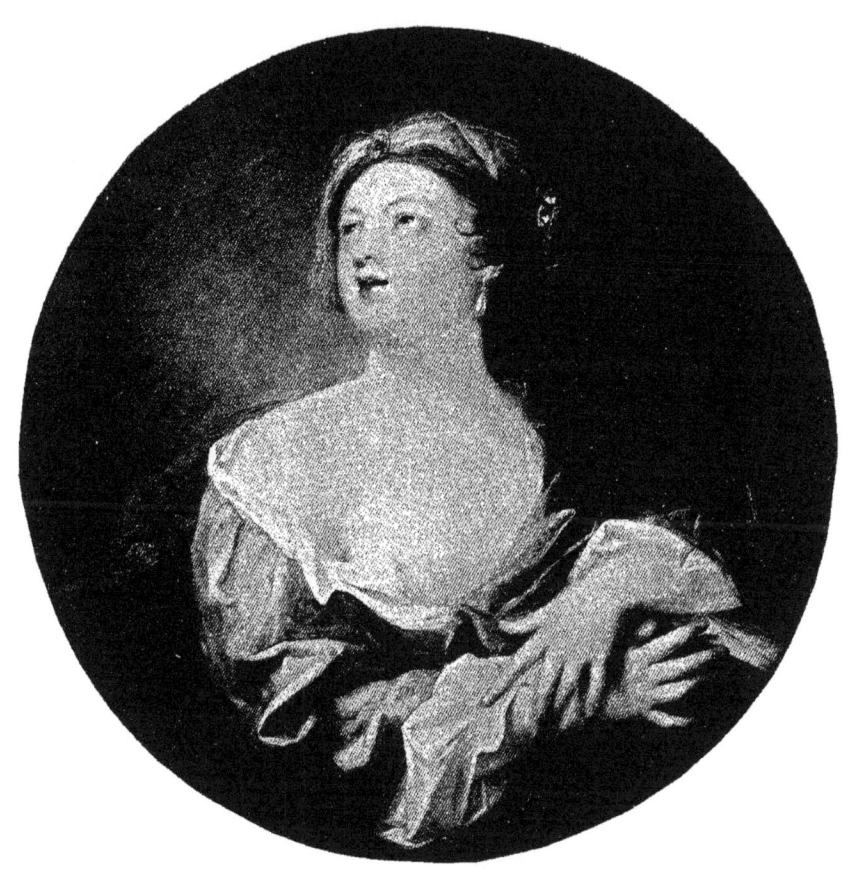

No. 48
J. A. GRIMEAUX

Claude Joseph Vernet
1714-1789

This celebrated French marine and landscape painter went to Rome at the age of 18 and remained 20 years in Italy. Returning to Paris, he soon attained great distinction and at one time was supposed to surpass every landscape painter in Europe

24 SACKING OF THE CASTLE

Peter Nedek
1616-1686

A Dutch painter, born at Amsterdam
Painted portraits and landscapes

25 THE DUTCH PEASANT

On panel

Jan David De Heem
1600-1674

Considered by many the greatest still-life painter of the Dutch school

26 STILL LIFE

On panel

Adrian Van der Werff

1659-1722

A Dutch painter who acquired the very highest reputation during his life. Few painters have carried finishing to so high a pitch

27 IDEAL HEAD

On panel

H. Rigaud

1659-1743

Considered one of the best portrait painters of the early French school

28 PORTRAIT OF A COUNCILOR

Durk Van Bergen

1645-1869

A Dutch landscape and cattle painter, the ablest scholar of Adrian Van der Velde, whose charming style he followed

29 LANDSCAPE AND CATTLE

On panel

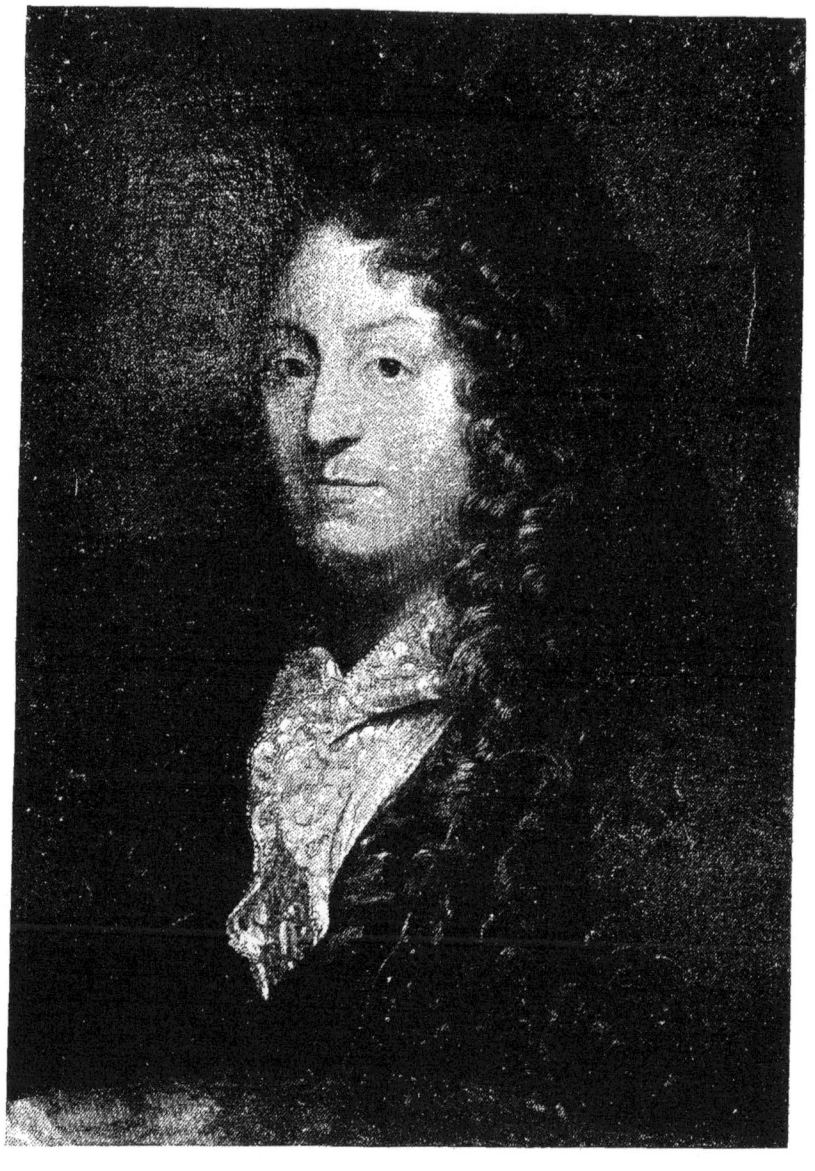

No. 52 PIERRE MIGNARD

Charles Jervas

1675-1739

Born in Ireland, but became a pupil of Kneller in London and continued his studies in Paris and Rome. His portraits reveal a fine quality

30 PORTRAIT OF A GENERAL

J. M. Nattier

1642-1705

31 PORTRAIT OF A LADY

Thomas Barker

Of Bath

1769-1847

An original English painter of landscape and rural life. Was exceedingly popular during his career

32 ENGLISH PEASANT

Abraham Begyn

1650-1710

A Dutch painter who painted landscapes and cattle in the style of Berghem. His works are greatly admired and esteemed

34 LANDSCAPE WITH CATTLE

Jacob Jordaens

1594-1678

35 FLEMISH BEAUTY

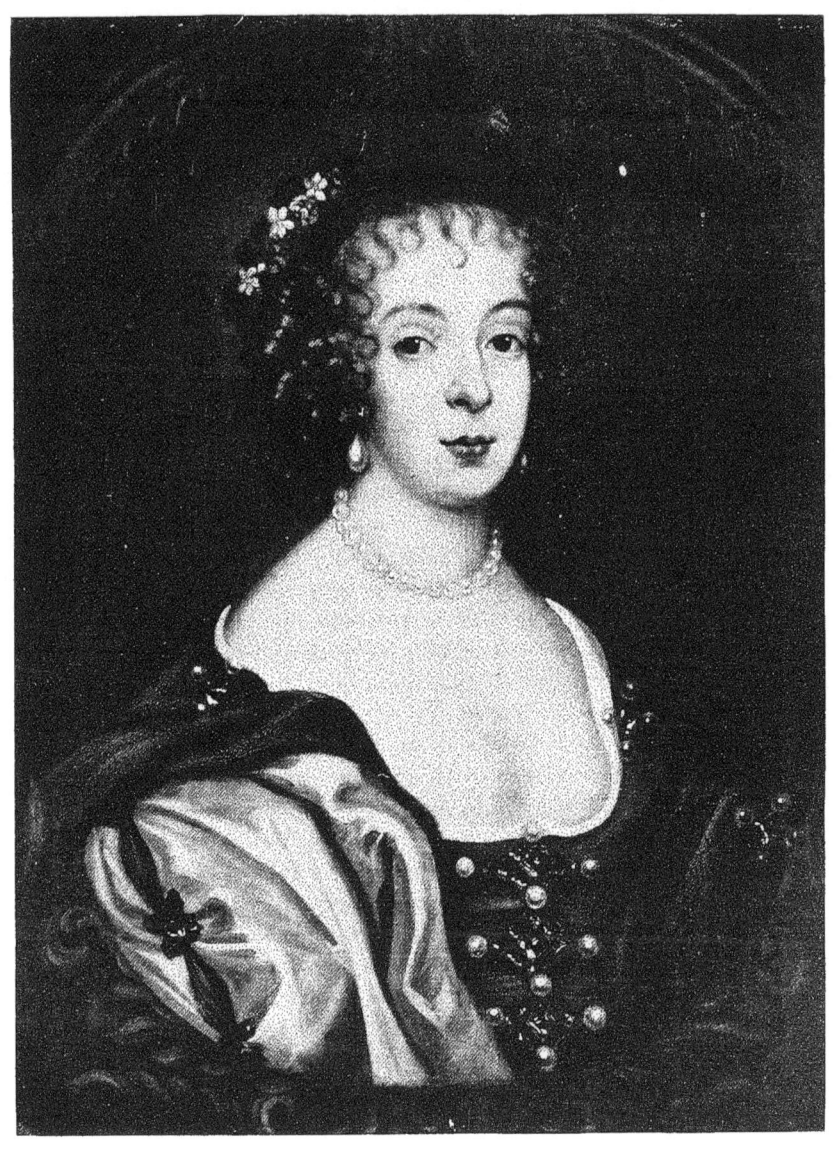

No. 62 SIR GODFREY KNELLER

C. Seybold

1697-1768

This German artist is especially known by his portraits in which he was a follower of Denner. Pictures by his hand are contained in the Royal galleries of Vienna and Dresden

36 THE DUTCH BOY

Sir Joshua Reynolds

1723-1792

The great master of portraits of the English school. His life and work are too well known to need comment

37 THE HON. GEORGE GREVILLE

Francis Cotes

1726-1770

An English portrait painter, very pleasing in his drawing and coloring

G. Michel

1763-1843

39 LANDSCAPE

Hans Holbein

1497-1543

The greatest portrait painter of the
old German school

40 PORTRAIT OF AN OLD MAN

On panel

B. Van der Helst

1613-1670

A noted portrait painter, who ranks high
in the Dutch school

41 PORTRAIT OF A LADY

Signed and dated 1645

N. V. Diaz

1809-1876

Is placed in the first rank of the Barbizon painters. Excelled both in landscape and in genre painting

42 GROUP OF CHILDREN

Baron H. Leys

1815-1869

A renowned artist of the modern Flemish school

43 OUTSIDE THE INN

On panel

Pierre Mignard

1610-1695

44 THE DUCHESS OF MONTPENSIER

T. H. de Keyser

1630

A Dutch artist of very great reputation, who devoted himself principally to the painting of portraits

45 PORTRAIT OF A YOUNG MAN

On panel

Jan Van Ravesteyn

1580-1657

A Dutch portrait painter, who is said not to have been surpassed in his particular line by any of his contemporaries, with the exception of Rubens and Van Dyck

46 PORTRAIT OF A LADY

On panel

William Dobson

1610-1646

47 JAMES STRADBROOKE

No. 66. GEORGE MORELAND

Jean Alexis Grimoux

1680-1740

A Swiss portrait painter who spent most of his life in Paris and was a member of the French Academy

48 ADRIENNE LECOUVREUR

Francesco Guardi

1712-1793

A Venetian painter, pupil of Canaletto, and, like his master, devoted to architectural subjects

49 VENETIAN SCENE

J. B. Crome

1793-1842

Son of the great landscape artist, John Crome, and approximates his father in quality. His moonlight scenes have been considered especially poetical

50 MOONLIGHT

57 AN OLD MAN

On panel

C. Bonesi

1653-1725

A Bolognese painter, whose best works are in the churches and public edifices of Bologna

58 HOLY FAMILY

J. C. Ibbetson

1759-1817

A talented English landscape artist

59 LANDSCAPE AND FIGURES

No. 68 N. DE LARGELLIERE

Georges Michel
1763-1813

A favorite French landscape painter. His favorite subject was the great plain, which stretches from Montmortre to St Denis, there he found subjects for hundred of pictures

60 THE GATHERING STORM

On panel

Jacob Jordaens
1594-1678

Considered the best pupil of Rubens, to whom some of his best works have often been attributed

61 THE GUARDSMAN

On panel

Sir Godfrey Kneller
1646-1723

Born in Germany, studied in Italy and went to England when he was 30 years of age, where he remained until his death He achieved a great reputation as a portrait painter, was patronized by royalty and accumulated a large fortune

62 NELL GWYNN

Jan Mienze Molenaer

1660

A really great example of an eminent Dutch artist. Molenaer painted somewhat in the manner of Jan Steen, but always maintained his own individuality

63 DANCE IN THE TAVERN

Jan Miel

1599-1664

Born near Antwerp. Studied under Van Dyck. Went to Italy early in life, remaining there until his death. He devoted himself principally to landscape painting, which he ornamented with figures; but his paintings betray a strong Italian influence. His works are admired for the brilliancy of their coloring and the clearness of their tints

64 ITALIAN MARKET SCENE

Jan Van Goyen

1596-1656

A Dutch landscape painter, whose pencil is exceedingly light and spirited. Always a favorite artist among collectors of the Dutch school

65 THE DUTCH MILL
 On panel

George Morland
1764-1804

Has been considered inimitable in portraying the broad and bucolic walks of life. It is said that the Hog was his favorite animal. The sincerity and happy tone of his paintings have brought his works into wide spread demand

66 MAID AND PIGS

N. N. Coypel
1692-1734

A French artist, known for his rich designs and elegant forms

67 PORTRAIT OF THE COUNTESS OF MALEZIEUX

N. de Largilliere
1656-1746

The portraits of this emenent French artist are drawn with great fidelity. His penciling is light and spirited, and his coloring exceedingly chaste and delicate. He painted the portraits of both the English and French Courts

68 A FRENCH NOBLEMAN

Jean Raoux

1677-1734

An unusually fine specimen of this French master, whose highly decorative portraits are well known and greatly appreciated

69 "THE CONCERT"
(A LADY AND HER CHILDREN)

Albert Adam

1786

German painter of portraits and landscapes
Painted the portraits of Napoleon and his staff

70 PORTRAIT OF GOETHE
At age of 21
On panel

George Henry Harlow

1787-1819

A pupil of Sir Thomas Lawrence and a very successful English portrait painter

71 PORTRAIT OF A LADY

No. 101 ALEXANDRE ROSLIN

A. Van Dyck

1599-1641

An exceedingly fine painting of this great Flemish master

72 THE ENTOMBMENT

On panel

Jan Verspronck

1597-1662

An excellent Dutch portrait painter

73 PORTRAIT OF A GENTLEMAN

Cornelius Janssen

1590-1665

A Dutch portrait painter of considerable reputation, who visited England, and was a favorite at the court of James I.

74 PORTRAIT OF A LADY

Felix Ziem

1822.

Modern French school. One of the greatest colorists of our time

75 VENICE

J. de Heusch

1657-1701

A Dutch painter who went to Italy early in life and devoted himself to the study of the works of Salvator Rosa, meeting with considerable success

76 OLD CASTLE AND FIGURES

On panel

J. W. M. Turner

1775-1851

Greatest landscape artist of the English school

77 THE CASTLE ON THE HILL

Artist Unknown

78 RAPHAEL AND PERUGINO

Thomas Sully

1783-1872

Born in England, he came to America in his ninth year, first studying art in Charleston. He is noted for his early American portraits.

79 BOY'S HEAD

T. Rowlandson

1756-1827

A talented English painter and engineer.

80 (a) THE DERBY
 (b) THE MALL

Water color drawings. From the collection of the Duc de Chaulnes

No 104　　　　　　　　　　　　　　　　GEORGE ROMNEY

SECOND EVENING'S SALE

On Friday, April 29th, 1904,

at 8.15 o'clock

J. B. C. Corot

1796-1875

81 ORIGINAL PEN AND INK DRAWING

From the Corot sale

Ag. Caracci

1558-1601

A splendid Italian artist,

F. Willems

1816

A Flemish painter of note

83 LADY AND YOUNG MAN READING

On panel

W. C. Heda

1594-1680

One of the great painters of still-life

of the Dutch school

84 STILL LIFE

C. M. A. Challe

1718-1778

Was a member of the French Academy and a favorite artist of the XVIII. Century

85 FRENCH INTERIOR, LOUIS XVI

On panel

Jacques Verryet

XVII. Century

A Flemish artist, who painted moonlights, etc. in the manner of Van der Neer

86 IN THE ROADSTEAD

On panel

Jacques Verryet

XVII. Century

87 THE SEA BREEZE

On panel

J. H. Fragonard

1732-1806

A pupil of Boucher. He perfected himself in Italy. His paintings are exceedingly graceful and attractive

88 GIRL WITH COWS

On panel

J. B. Jongkind

1819-1891

Modern Dutch school. Pupil of Isabey

89 RIVER SCENE

Jules Dupre

1811-1879

One of the greatest landscape painters of the modern French school

90 LANDSCAPE WITH CATTLE

N. de Largilliere

1656-1746

91 PORTRAIT OF A LADY WITH ROSE

No. 123 M. Q. DE LA TOUR

John Crome

1769-1821

92 STORMY CLOUDS

On panel

E. Loyal Field

(Contemporary)

93 LANDSCAPE

John Pieters

1667-1727

A Flemish painter who went to England and worked in conjunction with Sir Godfrey Kneller

94 LADY WITH BOOK

A. Van der Kabel

1631-1695

A Dutch painter. Pupil of Van Goyan, who afterwards worked in Italy under the influence of Salvator Rosa

95 LANDSCAPE AND MILL

On panel

John Rathbone

1750-1807

An English artist, who by the diligent study of nature acquired distinction as a landscape painter

96 A SUMMER LANDSCAPE

On panel

J. M. Nattier

1685-1766

97 PORTRAIT, MLLE. DE CHAROLAIS

H. Rigaud

1659-1743

98 PORTRAIT OF A GENTLEMAN

N. V. Diaz

1809-1876

99 BY THE WOODS

A. Van Croos

1650

A Dutch painter who generally painted river views
in the style of Van Goyen

100 IN THE CHANNEL

On panel

1733-1793

A Swiss portrait painter, who established himself in Paris, and was elected a member of the French Academy

101 PORTRAIT OF A YOUNG MAN

Andries Both

1609-1640

Charming picture of one of the best landscape painters of the Dutch school, Both visited Italy and the Italian influence is betrayed in his warm and tender landscapes

102 LANDSCAPE AND CATTLE

Jan Van Hugtenburg

1646-1733

A Dutch artist who gained high reputation for his admirable battle pieces. This is an unusually fine example of the artist

103 THE ARTIST

D. TENIERS

No. 139

George Romney

1734-1802

104 PORTRAIT OF LADY
 ELIZABETH FORBES

A. Van der Meulin

1634-1690

A Flemish landscape painter of reputation. On a visit to France he was greatly patronized by Louis XIV.

105 WINTER SCENE

 On panel

J. M. Nattier

1642-1705

106 PORTRAIT OF A LADY

Georges Michel
1763-1843

107 THE COUNTRY ROAD

G. Terburg
1608-1681

This famous Dutch painter acquired great reputation in Germany, Italy and France; painted the portraits of the celebrated men of his time. He was knighted by the King of Spain, and munificently rewarded

108 PORTRAIT OF SCHOLAR

M. J. Mierevelt
1567-1641

One of the most admired portrait painters of the Dutch school

109 PORTRAIT OF A LADY

On panel

J. B. C. Corot

1796-1875

The greatest painter of landscape of his time

110 LANDSCAPE

Eugene L. G. Isabey

1804-1886

A famous French painter, especially of marines

111 HAULING THE NET

F. Drouais

1727-1775

112 PORTRAIT OF LADY

J. B. Pater

1696-1736

A pupil of Watteau, all of whose paintings have a distinct charm

113 THE FISHING PARTY

On panel

N. V. Diaz

1807-1876

114 FOREST DE FONTAINEBLEAU

On panel

John Crome

1769-1821

Founder of the Norwich landscape school of painting. His work has steadily gained in the appreciation of art connoisseurs

O. 140 JACOB RUISDAEL

Lucas Cranach (The Younger)

1515-1586

Of the old German school, largely a follower of his father and of Albert Durer

116 THE YOUNG ASTRONOMER

On panel

Francesco Bassi

1664-1693

This Bolognese painter, although he died at the early age of 29, left some works of great merit. He was a distinguished follower of Guercino

117 IDEAL HEAD

M. Q. De la Tour

1704-1788

A celebrated French portrait painter

118 FRENCH LADY

The signature of the artist is partly erased, but the

J. Biltius

1651

A Dutch painter distinguished for his representations of dead game, etc., which he painted with wonderful fidelity.

119 STILL LIFE

Gerard Alberts

1750

A Dutch artist who painted portraits after the manner of Godfrey Kneller

120 PORTRAIT OF A LADY

Andries Both

1609-1640

121 THROUGH THE PASS

Portrait of the Countess de Chatenay
and her Children

M. Q. De la Tour

1704-1788

123 PORTRAIT OF A CAVALIER

B. Bremberg

1620-1663

An eminent Dutch painter who spent nearly all of his life in Italy. His most successful works are small in size

John Glover

1767-1849

A good English landscape painter, who executed many works in Australia. His art was fashionable and commanded good prices during his life time

125 LANDSCAPE WITH CATTLE

Francesco Guardi

1712-1793

126 VENETIAN SCENE

Salomon Ruisdael

1616-1670

The elder brother of the famous Jacob Ruisdael, but his paintings rather follow the manner of John Van Goyen

127 THE RUSTIC BRIDGE

Sir Godfrey Kneller

1646-1723

128 PORTRAIT OF A GENTLEMAN

George Romney

1734-1802

Now placed in the front rank of the great
English portrait painters

129 PORTRAIT OF A LADY

Gustave Dore

1833-1883

Dore was the greatest illustrative painter that ever lived. The example of this collection is particularly fine and conveys an adequate conception of his unusual talent

Carlo Dolci
1616-1686

This distinguished Italian painter acquired reputation by the appropriate composition, pleasing coloring, graceful character and general harmony of his works

131 AMOR

William Dobson
1610-1646

An unusually fine example of this great English artist, who approached nearest to the excellence of Van Dyck. Sir Joshua Reynolds characterized him as one of the greatest artists England has produced.

132 ADMIRAL ROBERT BLAKE

Jean B. Greuze
1726-1805

An eminent French painter of fancy subjects, expecially of girls and children. His works are highly prized

133 GIRL WITH BIRD

1803-1902

A famous English painter of cattle pieces

134 CATTLE PIECE

J. B. Crome

1793-1842

135 THE PEASANT'S HOME

On panel

J. F. Herring

1795-1865

English artist who devoted himself to painting animals, especially horses. Received commissions from Queen Victoria

136 HORSE AND HOSTLER

1660

The paintings of this able Dutch artist are so closely related to those of Hobbema that they are often confounded with those of that celebrated master

137 THE WATERMILL

Peter Paul Rubens
1577-1640

A replica in smaller size of a part of the famous St. Cecelia of the Berlin Gallery

138 ST CECELIA

David Teniers
1610-1694

A splendid example of one of the most distinguished artists of the Flemish school. In all his works he shows a lively and fertile invention and great facility of execution. His superior examples possess a beautiful transparency and do not suffer if examined with the strongest magnifying glass

139 TAVERN SCENE

Signed at the lower left

On panel

No. 141 F. H. DROUAIS

Jakob Ruisdael
1630-1682

Considered the most eminent landscape painter of the Dutch school. This painting is an unusual example of his agreeable style

140 AT THE BROOKSIDE

Francois Hubert Drouais
1727-1775

This French portrait painter became so distinguished in his time that he was not only called to execute the portraits of Royalty, but also no famous personage or beautiful woman of his day but that insisted on having a portrait painted by his hand. His exquisite portraits in the Louvre Gallery are well known

141 LADY'S PORTRAIT

Hubert von Eyck
1366-1426

An important painting of this great Flemish master

142 TRIPTYCH: SAINTS
From the collection of Cardinal Fesch

D. Mytens
1671

A Dutch portrait painter of distinction

143 PORTRAIT OF A LADY

From the collection of E. Le Roy, Brussels

John Henry Roos
1631-1685

A Dutch artist, who became one of the most celebrated animal and landscape painters of his time. His landscape is always pleasing; his animals accurately painted after nature, and his coloring fresh and vigorous

144 ITALIAN SCENE WITH CATTLE

J. S. Soolmaker
1650

A splendid example of this Dutch artist, who painted wholly in the style of Nicholas Berchem. His paintings all show Italian influence and are noted for their spirit and color.

145 AT THE FOUNTAIN

On panel

J. M. Nattier
1685-1766

A fine decorative example of this distinguished French artist. His works harmonize so thoroughly with our modern Louis XIV. and Louis XVI., that they are in great demand

146 PORTRAIT OF MADAME DU BARRY, AS DIANA

From the collection of Count de Chambrun

On panel

Albert Klomp
1632

A Dutch artist who painted most successfully in the manner of Paul Patter

147 COW AND SHEEP

Antoine Vestier
1740-1810

Painted large and small portraits characterized by grace and attractive color

148 LADY WITH BOUQUET

A. Van der Meulin

1634-1690

149 DUTCH RIVER SCENE

Gabriel Van Leeuw

1643-1688

A very capable landscape and animal painter of the Dutch school

150 CATTLE PIECE

E. Van der Poel

1650

A remarkable painter of the Dutch school, whose pictures of conflagrations are especially noted

151 THE CONFLAGRATION

On panel

Peter Molyn

1637-1701

A Dutch artist of considerable ability

152 MOUNTAIN LANDSCAPE

On panel

John Peter Mueller

1783-1854

A Danish landscape painter of good reputation

153 THE TORRENT

Frans Hals

1584-1666

After Rembrandt considered the best painter of the Dutch school

James O'Connor

1793-1841

A native of Dublin, pupil of his father.
He spent many years in Paris

155 GLENMIRE BRIDGE

G. H. Turner

1814

156 WINDSOR CASTLE AND DEER PARK

T. H. de Keyser

1630

157 PORTRAIT OF A LADY

On panel

E. Van Marcke

1827-1890

A pupil of Troyon and an animal painter

of distinction

158 COW AND LANDSCAPE

J. F. Detroy

1679-1752

A French painter of portraits and historical subjects

159 PORTRAIT OF A BOY

R. Allegre

Modern French school. Received medals
from the Paris salon

160 VENICE

William Thompson

1726-1798

A good English painter who also achieved reputation as a writer on fine arts

161 SCOTCH LANDSCAPE

M. G. Mendez

Contemporary

162 SHE LOVES ME

On panel

JAMES P. SILO,
 Auctioneer.

Lightning Source UK Ltd.
Milton Keynes UK
UKHW021647200219
337573UK00004B/214/P